The ButtHurt Coloring Book

This book is dedicated to republicans and democrats.

Disclaimer: All characters, companies, events, places mentioned in the book are purely fictitious, any similarity with a person or company or event or place is purely coincidental.

Copyright © 2019 - 2039 Monald Trumpet
All rights reserved. No text of this book may be reproduced in any form by any electronic or mechanical means, including information storage and retrieval systems, without written permission from the publisher or author, except in the case of a reviewer, who may quote brief passages embodied in critical articles or in a review.

Introduction

President Trump is causing millions of butt-hurts at the speed of light, be it democrats, be it media spreading fake news, be it American celebrities, be it Iran, be it North Korea. He minces no word to get people butt-hurt. Please gift "The Butthurt Coloring Book" to your liberal friends/colleagues/family members so that they can note down the details of Butt-hurt in this book itself and cool their nerves by coloring 24 Awesome pictures of President Trump. Let's make the art of hurting butt great again. Hail America.

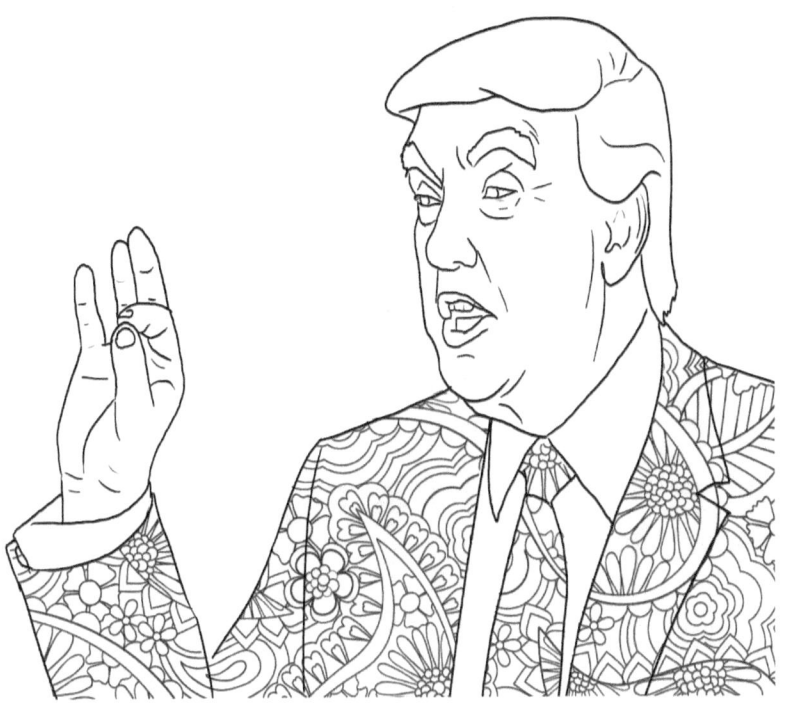

BUTTHURT REPORT

Date: _____ Time: _____

What is the Reason?
☐ Someone posted it ☐ Offensive picture on the internet

Was Tissue Needed?
☐ Yes ☐ No

Can you forget it?
☐ Yes ☐ No ☐ Not sure

Why are you filing report?
☐ I am an idiot. ☐ I'm better than everyone else.
☐ I am a crybaby. ☐ I'm a prude.
☐ I am thin-skinned. ☐ It wasn't my joke.
☐ I am a little bitch. ☐ No one liked my selfies today.
☐ I want my mommy! ☐ Life just isn't fair!
☐ I felt picked on. ☐ Other (please explain below):

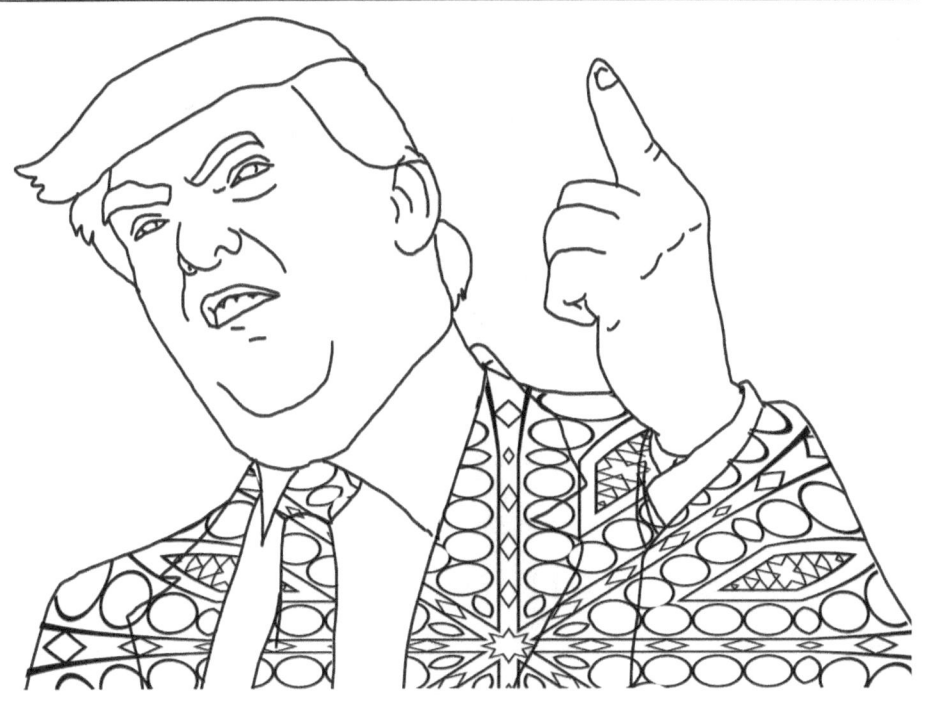

BUTTHURT REPORT

Date: _____ Time: _____

What is the Reason?
☐ Someone posted it ☐ Offensive picture on the internet

Was Tissue Needed?
☐ Yes ☐ No

Can you forget it?
☐ Yes ☐ No ☐ Not sure

Why are you filing report?
☐ I am an idiot.
☐ I am a crybaby.
☐ I am thin-skinned.
☐ I am a little bitch.
☐ I want my mommy!
☐ I felt picked on.
☐ I'm better than everyone else.
☐ I'm a prude.
☐ It wasn't my joke.
☐ No one liked my selfies today.
☐ Life just isn't fair!
☐ Other (please explain below):

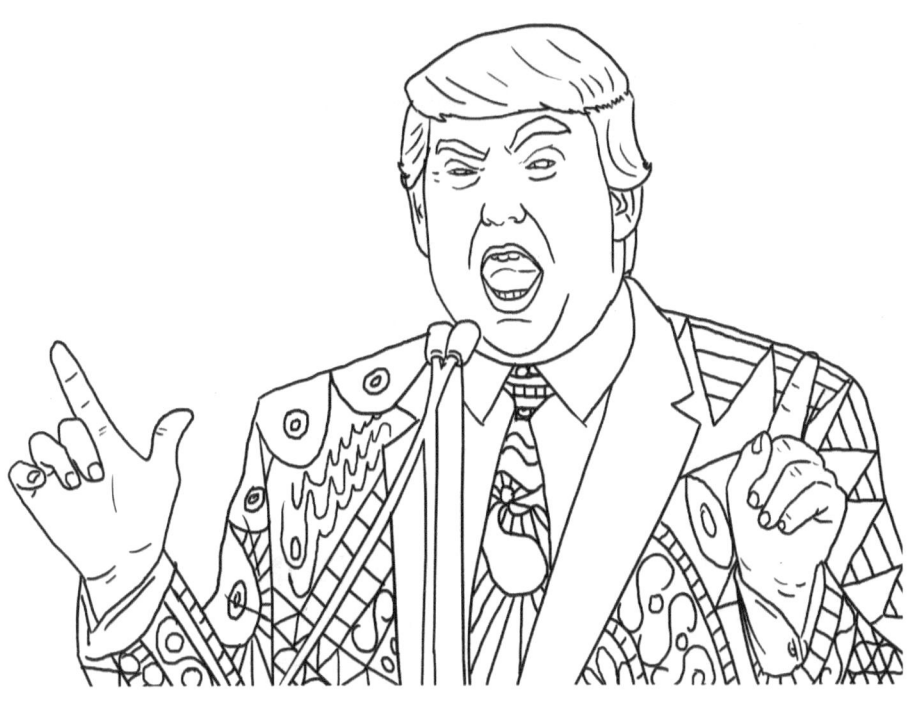

BUTTHURT REPORT

Date: _____ Time: _____

What is the Reason?
☐ Someone posted it ☐ Offensive picture on the internet

Was Tissue Needed?
☐ Yes ☐ No

Can you forget it?
☐ Yes ☐ No ☐ Not sure

Why are you filing report?
☐ I am an idiot.
☐ I am a crybaby.
☐ I am thin-skinned.
☐ I am a little bitch.
☐ I want my mommy!
☐ I felt picked on.
☐ I'm better than everyone else.
☐ I'm a prude.
☐ It wasn't my joke.
☐ No one liked my selfies today.
☐ Life just isn't fair!
☐ Other (please explain below):

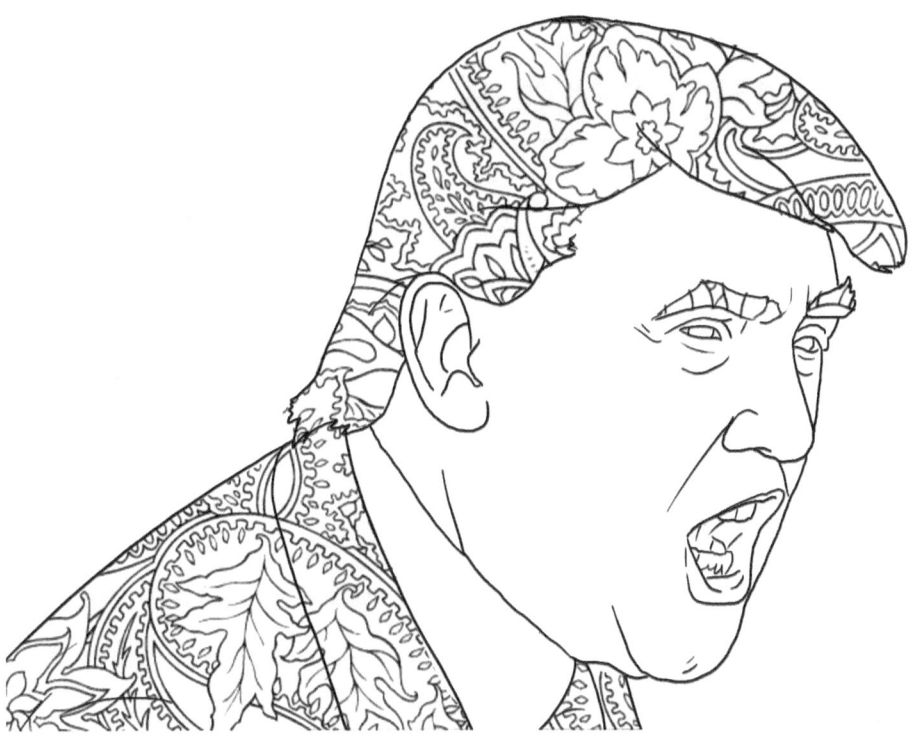

BUTTHURT REPORT

Date: _____ Time: _____

What is the Reason?
☐ Someone posted it ☐ Offensive picture on the internet

Was Tissue Needed?
☐ Yes ☐ No

Can you forget it?
☐ Yes ☐ No ☐ Not sure

Why are you filing report?
☐ I am an idiot.
☐ I am a crybaby.
☐ I am thin-skinned.
☐ I am a little bitch.
☐ I want my mommy!
☐ I felt picked on.
☐ I'm better than everyone else.
☐ I'm a prude.
☐ It wasn't my joke.
☐ No one liked my selfies today.
☐ Life just isn't fair!
☐ Other (please explain below):

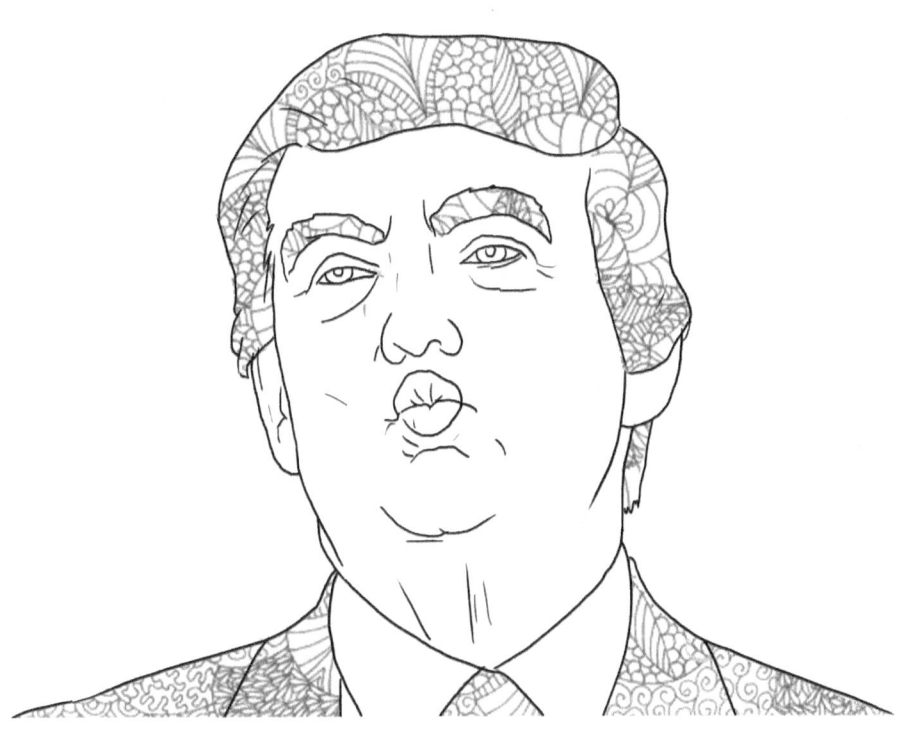

BUTTHURT REPORT

Date: _____ Time: _____

What is the Reason?
☐ Someone posted it ☐ Offensive picture on the internet

Was Tissue Needed?
☐ Yes ☐ No

Can you forget it?
☐ Yes ☐ No ☐ Not sure

Why are you filing report?
☐ I am an idiot.
☐ I am a crybaby.
☐ I am thin-skinned.
☐ I am a little bitch.
☐ I want my mommy!
☐ I felt picked on.
☐ I'm better than everyone else.
☐ I'm a prude.
☐ It wasn't my joke.
☐ No one liked my selfies today.
☐ Life just isn't fair!
☐ Other (please explain below):

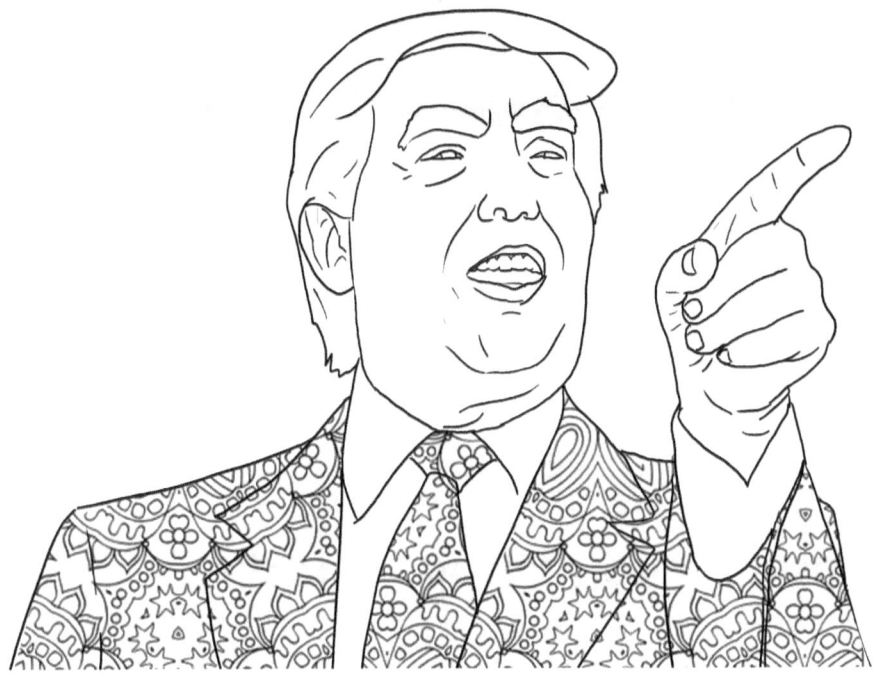

BUTTHURT REPORT

Date: _____ Time: _____

What is the Reason?
☐ Someone posted it ☐ Offensive picture on the internet

Was Tissue Needed?
☐ Yes ☐ No

Can you forget it?
☐ Yes ☐ No ☐ Not sure

Why are you filing report?
☐ I am an idiot.
☐ I am a crybaby.
☐ I am thin-skinned.
☐ I am a little bitch.
☐ I want my mommy!
☐ I felt picked on.
☐ I'm better than everyone else.
☐ I'm a prude.
☐ It wasn't my joke.
☐ No one liked my selfies today.
☐ Life just isn't fair!
☐ Other (please explain below):

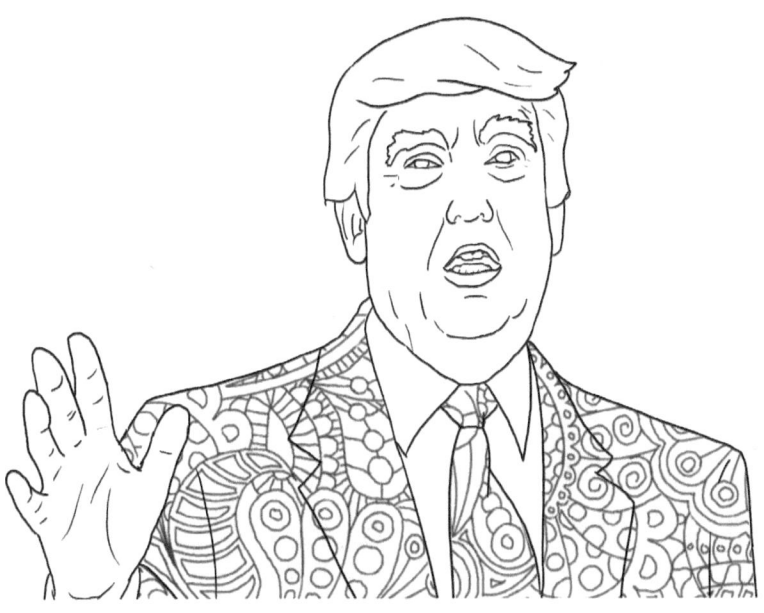

BUTTHURT REPORT

Date: _____ Time: _____

What is the Reason?
☐ Someone posted it ☐ Offensive picture on the internet

Was Tissue Needed?
☐ Yes ☐ No

Can you forget it?
☐ Yes ☐ No ☐ Not sure

Why are you filing report?
☐ I am an idiot. ☐ I'm better than everyone else.
☐ I am a crybaby. ☐ I'm a prude.
☐ I am thin-skinned. ☐ It wasn't my joke.
☐ I am a little bitch. ☐ No one liked my selfies today.
☐ I want my mommy! ☐ Life just isn't fair!
☐ I felt picked on. ☐ Other (please explain below):

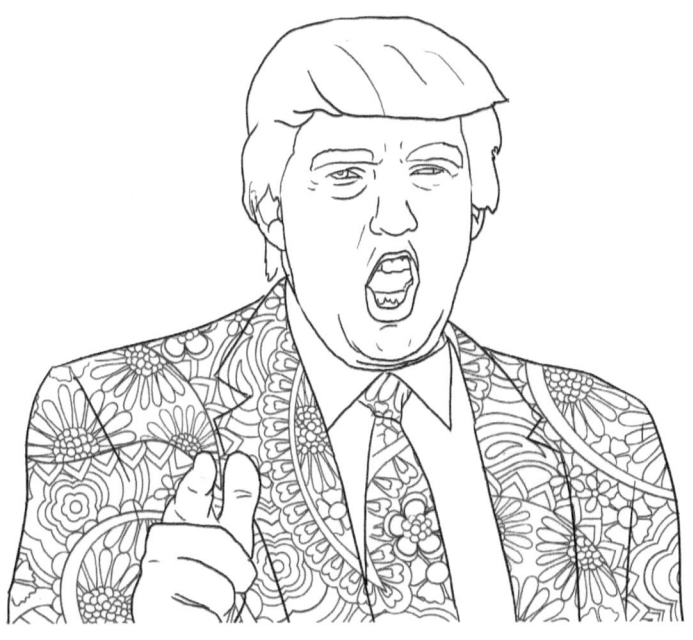

BUTTHURT REPORT

Date: _____ Time: _____

What is the Reason?
☐ Someone posted it ☐ Offensive picture on the internet

Was Tissue Needed?
☐ Yes ☐ No

Can you forget it?
☐ Yes ☐ No ☐ Not sure

Why are you filing report?
☐ I am an idiot. ☐ I'm better than everyone else.
☐ I am a crybaby. ☐ I'm a prude.
☐ I am thin-skinned. ☐ It wasn't my joke.
☐ I am a little bitch. ☐ No one liked my selfies today.
☐ I want my mommy! ☐ Life just isn't fair!
☐ I felt picked on. ☐ Other (please explain below):

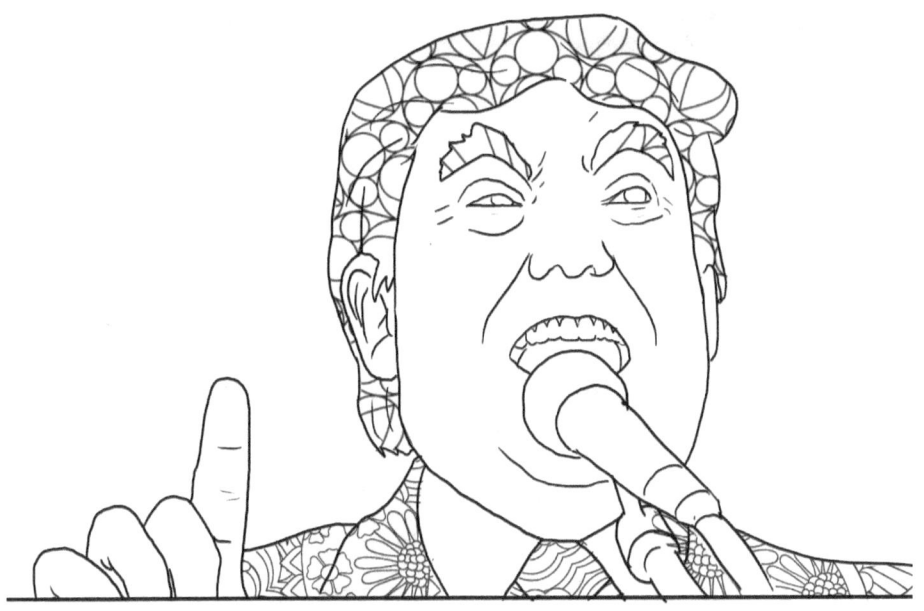

BUTTHURT REPORT

Date: _____ Time: _____

What is the Reason?
☐ Someone posted it ☐ Offensive picture on the internet

Was Tissue Needed?
☐ Yes ☐ No

Can you forget it?
☐ Yes ☐ No ☐ Not sure

Why are you filing report?
☐ I am an idiot.
☐ I am a crybaby.
☐ I am thin-skinned.
☐ I am a little bitch.
☐ I want my mommy!
☐ I felt picked on.
☐ I'm better than everyone else.
☐ I'm a prude.
☐ It wasn't my joke.
☐ No one liked my selfies today.
☐ Life just isn't fair!
☐ Other (please explain below):

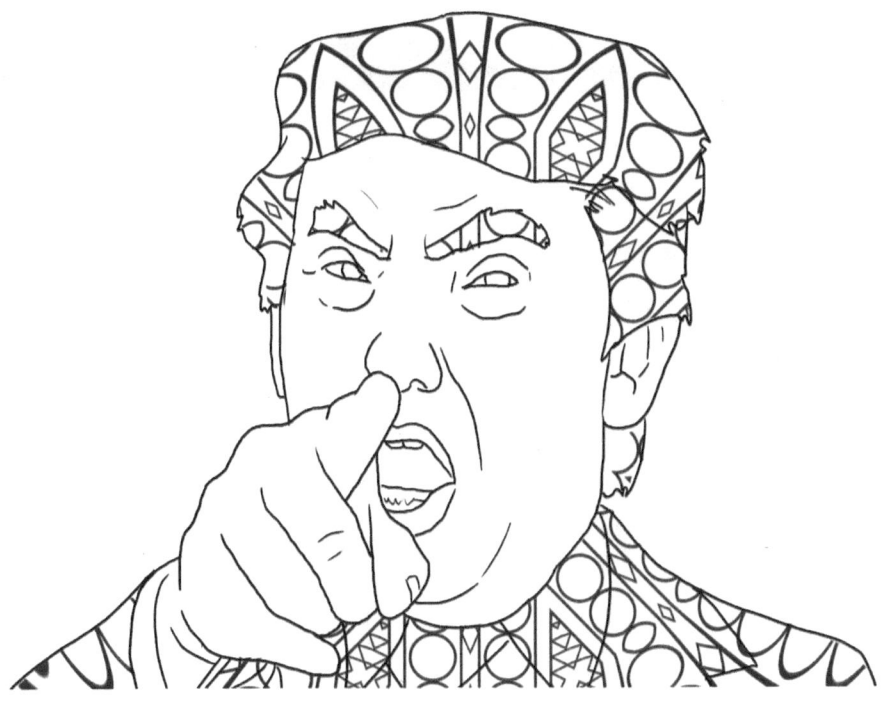

BUTTHURT REPORT

Date: _____ Time: _____

What is the Reason?
☐ Someone posted it ☐ Offensive picture on the internet

Was Tissue Needed?
☐ Yes ☐ No

Can you forget it?
☐ Yes ☐ No ☐ Not sure

Why are you filing report?
☐ I am an idiot.
☐ I am a crybaby.
☐ I am thin-skinned.
☐ I am a little bitch.
☐ I want my mommy!
☐ I felt picked on.
☐ I'm better than everyone else.
☐ I'm a prude.
☐ It wasn't my joke.
☐ No one liked my selfies today.
☐ Life just isn't fair!
☐ Other (please explain below):

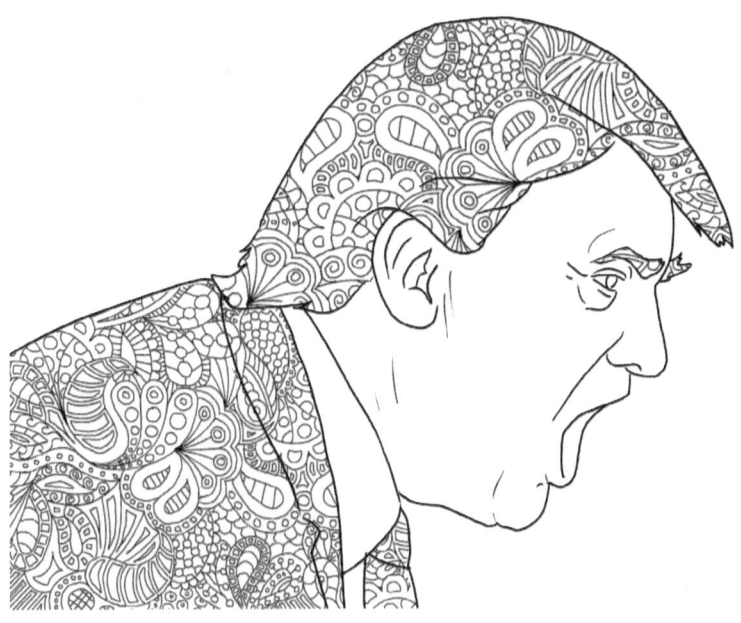

BUTTHURT REPORT

Date: _____ Time: _____

What is the Reason?
☐ Someone posted it ☐ Offensive picture on the internet

Was Tissue Needed?
☐ Yes ☐ No

Can you forget it?
☐ Yes ☐ No ☐ Not sure

Why are you filing report?
☐ I am an idiot.
☐ I am a crybaby.
☐ I am thin-skinned.
☐ I am a little bitch.
☐ I want my mommy!
☐ I felt picked on.
☐ I'm better than everyone else.
☐ I'm a prude.
☐ It wasn't my joke.
☐ No one liked my selfies today.
☐ Life just isn't fair!
☐ Other (please explain below):

BUTTHURT REPORT

Date: _____ Time: _____

What is the Reason?
☐ Someone posted it ☐ Offensive picture on the internet

Was Tissue Needed?
☐ Yes ☐ No

Can you forget it?
☐ Yes ☐ No ☐ Not sure

Why are you filing report?
☐ I am an idiot. ☐ I'm better than everyone else.
☐ I am a crybaby. ☐ I'm a prude.
☐ I am thin-skinned. ☐ It wasn't my joke.
☐ I am a little bitch. ☐ No one liked my selfies today.
☐ I want my mommy! ☐ Life just isn't fair!
☐ I felt picked on. ☐ Other (please explain below):

BUTTHURT REPORT

Date: _____ Time: _____

What is the Reason?
☐ Someone posted it ☐ Offensive picture on the internet

Was Tissue Needed?
☐ Yes ☐ No

Can you forget it?
☐ Yes ☐ No ☐ Not sure

Why are you filing report?
☐ I am an idiot.
☐ I am a crybaby.
☐ I am thin-skinned.
☐ I am a little bitch.
☐ I want my mommy!
☐ I felt picked on.
☐ I'm better than everyone else.
☐ I'm a prude.
☐ It wasn't my joke.
☐ No one liked my selfies today.
☐ Life just isn't fair!
☐ Other (please explain below):

BUTTHURT REPORT

Date: _____ Time: _____

What is the Reason?
☐ Someone posted it ☐ Offensive picture on the internet

Was Tissue Needed?
☐ Yes ☐ No

Can you forget it?
☐ Yes ☐ No ☐ Not sure

Why are you filing report?
☐ I am an idiot.
☐ I am a crybaby.
☐ I am thin-skinned.
☐ I am a little bitch.
☐ I want my mommy!
☐ I felt picked on.
☐ I'm better than everyone else.
☐ I'm a prude.
☐ It wasn't my joke.
☐ No one liked my selfies today.
☐ Life just isn't fair!
☐ Other (please explain below):

BUTTHURT REPORT

Date: _____ Time: _____

What is the Reason?
☐ Someone posted it ☐ Offensive picture on the internet

Was Tissue Needed?
☐ Yes ☐ No

Can you forget it?
☐ Yes ☐ No ☐ Not sure

Why are you filing report?
☐ I am an idiot.
☐ I am a crybaby.
☐ I am thin-skinned.
☐ I am a little bitch.
☐ I want my mommy!
☐ I felt picked on.
☐ I'm better than everyone else.
☐ I'm a prude.
☐ It wasn't my joke.
☐ No one liked my selfies today.
☐ Life just isn't fair!
☐ Other (please explain below):

BUTTHURT REPORT

Date: _____ Time: _____

What is the Reason?
☐ Someone posted it ☐ Offensive picture on the internet

Was Tissue Needed?
☐ Yes ☐ No

Can you forget it?
☐ Yes ☐ No ☐ Not sure

Why are you filing report?
☐ I am an idiot. ☐ I'm better than everyone else.
☐ I am a crybaby. ☐ I'm a prude.
☐ I am thin-skinned. ☐ It wasn't my joke.
☐ I am a little bitch. ☐ No one liked my selfies today.
☐ I want my mommy! ☐ Life just isn't fair!
☐ I felt picked on. ☐ Other (please explain below):

BUTTHURT REPORT

Date: _____ Time: _____

What is the Reason?
☐ Someone posted it ☐ Offensive picture on the internet

Was Tissue Needed?
☐ Yes ☐ No

Can you forget it?
☐ Yes ☐ No ☐ Not sure

Why are you filing report?
☐ I am an idiot. ☐ I'm better than everyone else
☐ I am a crybaby. ☐ I'm a prude.
☐ I am thin-skinned. ☐ It wasn't my joke.
☐ I am a little bitch. ☐ No one liked my selfies today
☐ I want my mommy! ☐ Life just isn't fair!
☐ I felt picked on. ☐ Other (please explain below):

BUTTHURT REPORT

Date: _____ Time: _____

What is the Reason?
☐ Someone posted it ☐ Offensive picture on the internet

Was Tissue Needed?
☐ Yes ☐ No

Can you forget it?
☐ Yes ☐ No ☐ Not sure

Why are you filing report?
☐ I am an idiot.
☐ I am a crybaby.
☐ I am thin-skinned.
☐ I am a little bitch.
☐ I want my mommy!
☐ I felt picked on.
☐ I'm better than everyone else.
☐ I'm a prude.
☐ It wasn't my joke.
☐ No one liked my selfies today.
☐ Life just isn't fair!
☐ Other (please explain below):

BUTTHURT REPORT

Date: _____ Time: _____

What is the Reason?
☐ Someone posted it ☐ Offensive picture on the internet

Was Tissue Needed?
☐ Yes ☐ No

Can you forget it?
☐ Yes ☐ No ☐ Not sure

Why are you filing report?
☐ I am an idiot.
☐ I am a crybaby.
☐ I am thin-skinned.
☐ I am a little bitch.
☐ I want my mommy!
☐ I felt picked on.
☐ I'm better than everyone else.
☐ I'm a prude.
☐ It wasn't my joke.
☐ No one liked my selfies today.
☐ Life just isn't fair!
☐ Other (please explain below):

BUTTHURT REPORT

Date: _____ Time: _____

What is the Reason?
☐ Someone posted it ☐ Offensive picture on the internet

Was Tissue Needed?
☐ Yes ☐ No

Can you forget it?
☐ Yes ☐ No ☐ Not sure

Why are you filing report?
☐ I am an idiot.
☐ I am a crybaby.
☐ I am thin-skinned.
☐ I am a little bitch.
☐ I want my mommy!
☐ I felt picked on.
☐ I'm better than everyone else.
☐ I'm a prude.
☐ It wasn't my joke.
☐ No one liked my selfies today.
☐ Life just isn't fair!
☐ Other (please explain below):

BUTTHURT REPORT

Date: _____ Time: _____

What is the Reason?
☐ Someone posted it ☐ Offensive picture on the internet

Was Tissue Needed?
☐ Yes ☐ No

Can you forget it?
☐ Yes ☐ No ☐ Not sure

Why are you filing report?
☐ I am an idiot.
☐ I am a crybaby.
☐ I am thin-skinned.
☐ I am a little bitch.
☐ I want my mommy!
☐ I felt picked on.
☐ I'm better than everyone else.
☐ I'm a prude.
☐ It wasn't my joke.
☐ No one liked my selfies today.
☐ Life just isn't fair!
☐ Other (please explain below):

BUTTHURT REPORT

Date: _____ Time: _____

What is the Reason?
☐ Someone posted it ☐ Offensive picture on the internet

Was Tissue Needed?
☐ Yes ☐ No

Can you forget it?
☐ Yes ☐ No ☐ Not sure

Why are you filing report?
☐ I am an idiot. ☐ I'm better than everyone else.
☐ I am a crybaby. ☐ I'm a prude.
☐ I am thin-skinned. ☐ It wasn't my joke.
☐ I am a little bitch. ☐ No one liked my selfies today.
☐ I want my mommy! ☐ Life just isn't fair!
☐ I felt picked on. ☐ Other (please explain below):

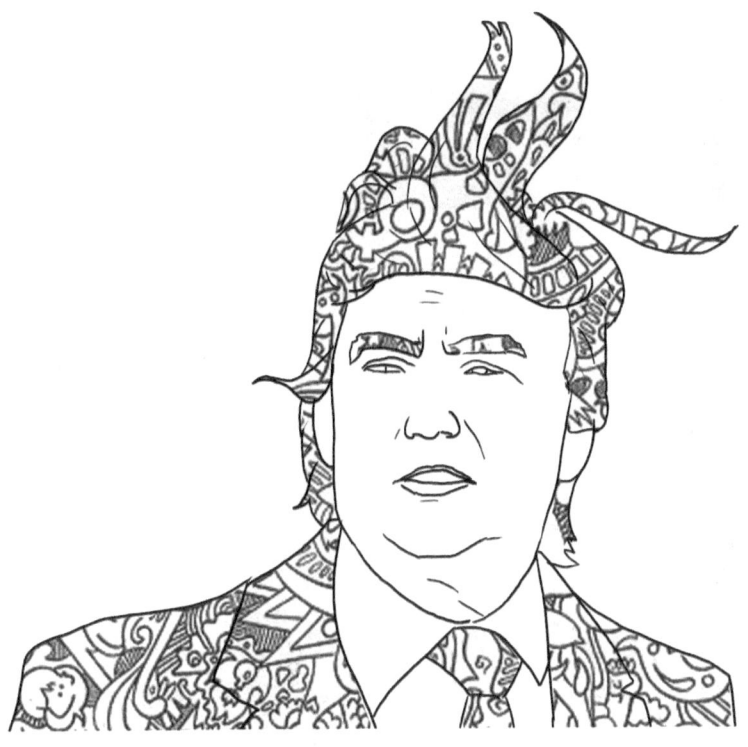

BUTTHURT REPORT

Date: _____ Time: _____

What is the Reason?
☐ Someone posted it ☐ Offensive picture on the internet

Was Tissue Needed?
☐ Yes ☐ No

Can you forget it?
☐ Yes ☐ No ☐ Not sure

Why are you filing report?
☐ I am an idiot. ☐ I'm better than everyone else.
☐ I am a crybaby. ☐ I'm a prude.
☐ I am thin-skinned. ☐ It wasn't my joke.
☐ I am a little bitch. ☐ No one liked my selfies today.
☐ I want my mommy! ☐ Life just isn't fair!
☐ I felt picked on. ☐ Other (please explain below):

About Author

Monald Trumpet is author of bestselling The Butthurt Coloring Book. If you would like to publish this book in a different language, please feel free to contact author's secretary at johntrumpet_@outlook.com

www.ingramcontent.com/pod-product-compliance
Lightning Source LLC
Chambersburg PA
CBHW030735180526
45157CB00008BA/3186